pastel

English translation © Copyright 1997
by Barron's Educational Series, Inc.
Original title of the book in Spanish is *Para empezar a pintar Pastel*
© Copyright Parramón Ediciones, S.A. 1996—World Rights
Published by Parramón Ediciones, S.A., Barcelona, Spain

Author: Parramón's Editorial Team
Illustrator: Parramón's Editorial Team

All inquiries should be addressed to:
Barron's Educational Series, Inc.
250 Wireless Boulevard
Hauppauge, New York 11788

Library of Congress Catalog Card No. 97-9414

International Standard Book No. 0-7641-0241-9

Library of Congress Cataloging-in-Publication Data
Para empezar a pintar pastel. English
 Learning to paint in pastel / [author, Parramón's Editorial Team;
illustrator, Parramón's Editorial Team].
 p. cm. — (Barron's art guides)
 ISBN 0-7641-0241-9
 1. Pastel drawing—Technique. I. Parramón Ediciones.
Editorial Team. II. Title. III. Series.
NC880.P2413 1997
741.2'35—dc21 97-9414
 CIP

Printed in Spain
98765432

BARRON'S ART GUIDES

LEARNING TO
PAINT IN
pastel

BARRON'S

Contents

MATERIALS

BASIC TECHNIQUES

I n pastel painting, the stick's high concentration of pigment helps create very attractive results, not only because of the range of textures it can produce but because of the intensity and purity of its colors. Although pastel painting does not require brushes, palette, or solvents of any type, it poses certain challenges for those who are unfamiliar with it.

This book has been created to facilitate learning the art of pastel. In it we give detailed explanations of techniques, from how to hold the color sticks, to how to paint the skin's various qualities by suggesting which colors to use. We will cover the most common methods employed as well as tricks of the trade. The beginner will discover step-by-step materials, styles, and fundamental elements of this art form. You begin with learning the basic concepts and end with being able to paint confidently using any pastel style.

Despite the valuable information contained in this book, you must not forget that, as a beginner, practice is essential for learning to paint how you like. It's essential to be patient and persevere in your work; this is the only way to acquire confidence and assurance with pastels.

Pastel

Pastel is a dry paint that is directly applied to paper. It is considered a direct technique because it does not require paintbrushes, palette, or solvents to paint a picture.

Characteristics

The name pastel comes from the word paste. Pastels are made up of pigments, water, and a binder. They are pressed into stick form for manageability.

Pastel is a dry paint form that does not require a tool to paint with. It's considered a direct technique since it's not diluted, nor does it require a palette or easel, or any special preparation.

The proportionally low quantity of binder in soft pastel sticks means they are particularly fragile and break easily.

What You Can Buy

Although pastels can be found in many different formats, they all have one thing in common: they come in stick form to be easily applied by hand.

SOFT STICKS

Soft pastel sticks are cylindrical in shape and measure about five centimeters (two inches) for manageability.

The main characteristic of soft pastels is that they are made with very little binder so that they adhere to the paper easily. This quality makes them the most popular pastels since they can be applied easily and are suitable for obtaining soft gradations in color.

One of the drawbacks to soft pastels is that they break easily and crumble into little pieces.

Due to a high quantity of pigment, soft pastels produce considerable color intensity when used for painting.

In art supply stores you will find soft pastels in half and whole sticks.

Quality and Recommendations

In order to become familiar with the pastel medium, we advise you to buy medium quality pastels and avoid those of higher quality. It could be said that higher quality pastels would be a better choice because of notable differences in intensity, color, and consistency. Furthermore, medium quality pastels have a lower proportion of pigment and working with them can be more difficult. However, the economic factor could be a barrier when you begin painting; a lower price may help you lose the fear of getting the paper dirty and encourage you to experiment more.

Soft pastel sticks can be bought individually or in boxes that contain anything from five to five hundred colors.

HARD STICKS

Hard pastel sticks are typically rectangular and contain more binding. They have been lightly baked so that they wear down more slowly. Hard sticks do not facilitate fusion and blending. This type of pastel is better suited for sketching as it's difficult to blend and has a more limited color range than the soft sticks.

Hard sticks.

PASTEL PENCILS

One of the benefits of this type of pastel is that you can use them without getting your hands dirty. On the other hand, the pencils are thinner, and therefore not suitable for painting large areas. Pastel pencils are generally used for sketch work or for complementary details in pastel painting.

OIL PASTELS

Oil pastels are similar to common pastels, although their mark is slightly different and the result is more like wax painting. Like oil paints, these pastel sticks can be dissolved with turpentine and used to create effects similar to those achieved with oil paints.

Oil pastels.

Having a small box of rice on hand is ideal for keeping the colors safe from fine dust.

Pastel pencils.

Paper

Paper is the most common support used in pastel painting. You can buy paper made specifically for pastel painting, although any paper that is not coated or excessively fine can be used as a support.

Characteristics

Pads of paper for pastel painting can be bought in various sizes.

Paper made specifically for pastel painting allows the colors to spread easily and adhere to the surface.

Many kinds of cardboard and drawing paper can perform this function as well, so you will have a wide selection of papers to choose from in terms of quality and price. It's not a good idea to use paper that weighs little as it is very thin and will tear easily when you apply pressure on the sticks. Avoid coated paper as well; the pastels' particles of pigment will not adhere to its polished surface.

What You Can Buy

Paper for both pastel painting and drawing is sold in art supply stores either in pads or individual sheets. Pad sizes vary from standard notebook size up to 100 cm × 70 cm (3 ft × 2.5 ft), which are the largest pads available. Individual sheets can be found in this size as well as in smaller 50 cm × 70 cm (1.5 ft × 2.5 ft) and larger 100 cm × 150 cm (3 ft × 5 ft) sizes.

Large pastel formats are painted on sheets that are sold separately or in packets of fifty. One drawback to these sheets is that if you want to paint smaller pictures, you must cut it to the desired size.

Quality and Recommendations

Paper quality in pastel painting is based on its capacity to retain the color on its surface as well as its ability to withstand the pressure applied when the painter blends and makes strokes and corrections that require erasing.

Therefore, any paper able to do all of the above can be used for pastel painting. You may familiarize yourself with pastels by experimenting on inexpensive paper and cardboard. (Some artists paint on packaging paper, then later reproduce their work on medium quality paper.)

With regard to choosing a paper size to start with, it's a good idea to begin using small formats, no bigger than 30 cm × 40 cm (1 ft × 1.5 ft) to avoid having to cover large areas. As you progress, you will discover what size suits you best.

The Paper's Color

Pastel paper comes, of course, in white but also in assorted colors. Colored paper is used quite often as it easily becomes an element of composition among the patches of color created by the pastels.

Colored paper is sold in pads and as loose sheets. Pads typically come in ranges of gray, umber, and so forth. The color of paper most commonly used in pastel painting is cream, a neutral white that aids the blending of colors; it is also less problematic than pure white.

There is a wide range of practical and economical sketchbooks. You can sketch and even paint with these as they retain color very well.

The Paper's Grain

The paper's grain is the relief or texture of the paper's surface. When painting with pastel, the paper's grain is an important element because as you paint the texture will be revealed. The choice between fine, medium, or coarse grain depends on you and the result you desire.

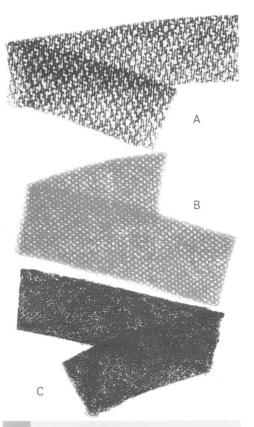

A. Guarro Watercolor, coarse grain. We mentioned that any paper can be used with pastels. Watercolor paper is especially noted for its rough quality. It also allows the artist to use water to remove pastel color without damaging the paper.

B. Canson Mi-teintes. This paper is made especially for pastels and comes in white and various colors. It has a different texture on each side, giving the artist two types of grain to work with. The medium grain on this side of the sheet is ideal for pastel painting.

C. Canson Mi-teintes. The other side of the sheet has a fine grain surface that is suitable for sketches and lines as well as for attention to details.

In fine art stores you will find paper in a range of colors for pastel painting. It can be bought in pads or as loose sheets.

Boards and Easels

The support used for pastel painting is paper. Paper's fragility and flexibility make it essential to attach it to a board. Once secured, you can apply the necessary pressure to the paper with the pastels.

Boards

Boards are an indispensable element in pastel painting because they are used to support and secure the paper, allowing the artist to work.

There are many types of boards. Selecting one depends on your preference, but typically they are made of plywood, which is sturdy, resistant, and light.

The size of the board should be five centimeters (two inches) wider on all sides than the largest size of paper you use. Then, even if you work in various formats, this one board is all that is necessary.

Plywood boards are light and resistant but you must make sure there are no knots and that the surface is polished.

Although particle board is much heavier than plywood, it has a coated surface and is smoother.

Choosing a Board

When you are selecting a board, there are several things to keep in mind. To begin with, it's difficult to find boards in an art supply store. You should be able to get one from a carpenter or lumberyard. Have them cut a board to the size you like. With respect to board size, make it five centimeters (two inches) more on each side than the paper size you use in order to secure the paper to it easily. A popular board size that is suitable for small to medium formats is 35 cm × 45 cm (14 in × 20 in).

The board's surface is another very important element. As you apply the sticks, the texture of the wood will appear on the paper and influence the result. Therefore, it's important that the board's surface be flat and smooth, without bumps or knots that will adversely affect your painting. Medium density particle board, which is much heavier than plywood, has a very smooth surface.

Easels

Easels perform an important function in pastel painting: they hold the board in place and make it possible to paint vertically. In this way the excess fine dust from the sticks will fall to the floor instead of getting your painting dirty. If you are painting on a table, keep in mind you must continually blow the excess dust from your pastels to prevent it from soiling your work.

If you are going to buy an easel for pastel painting, there are several styles to choose from. There are outdoor easels, which are portable and fold up. Studio easels are heavier, but more solid. There are also table easels, which are often used to accommodate smaller works.

If you have the space and your budget allows, the best option is a studio easel without wheels. If it does have wheels, they should be able to lock in place to prevent the easel from moving while you paint. If you are on a budget, a table easel is a good option. If you prefer painting standing up, it can be propped up on something high enough to allow you to do so. To keep it from moving, you can put a stopper under the legs.

The studio easel is the best and most expensive. However, it takes up a great deal of space and is difficult to transport.

The table easel or box easel is a good choice if you do not have much space. It's very practical for carrying tools and colors. You can set it up on any table or shelf. It comes with a palette for oil painting that, as a last resort, can be used as a board.

The outdoor easel is portable but lacks stability; if you paint with vigorous strokes that require excessive pressure on the support, it's not a good option.

Folders

Pastel paintings are extremely delicate; the colors can smear or come off easily. It is therefore essential that you secure your work with fixative and keep it in folders. Separate each painting with sulfured paper or any other paper that the pigments will not stick to.

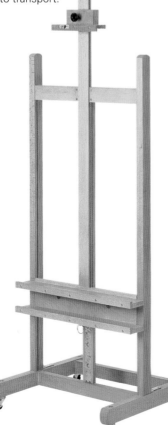

Box Sets

Because it is difficult to mix pastel colors, the artist must rely on a wide range of color sticks. Pastel sticks must be taken care of and stored safely as they are very fragile.

Box Sets

Boxes are necessary to store pastels in because the sticks are delicate and break easily. For this reason, pastel boxes usually contain sponge templates that protect the sticks and keep them separate, which prevents the pastels from rubbing off on one another.

What You Can Buy

In art supply stores there are box sets of all sizes. You will find small sets of six colors, used mostly for sketching, up to deluxe wooden boxes that may contain as many as three hundred sticks.

Recommendations

If you are going to buy pastel sticks, we suggest you begin with a small range of about fifteen colors and increase the number as you improve your technique. In this way you will discover the colors you need to complement your basic range. With additional sticks you can create your own unique range.

You should buy a boxed set of fifteen colors that will allow you to paint any subject. Later, buy an empty wooden box in which you can store the additional sticks needed to increase your range.

Both wooden and cardboard boxed sets contain a protective sponge. The main difference is that the wooden boxes usually contain higher quality pastels, although this is not always the case.

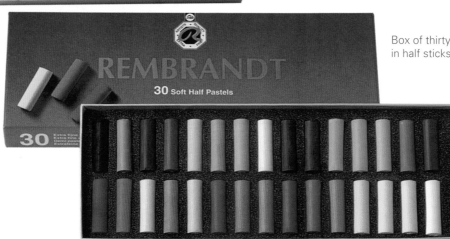

Boxed set of fifteen soft color pastels in whole sticks.

Box of thirty soft color pastels in half sticks.

Empty wooden boxes are usually big enough to accommodate boxed sets with sponges.

Hard pastels are stronger than soft pastels and thus are sold without a protective sponge. They are usually separated by plastic or cardboard. The color range of these pastels is not as extensive as that of soft pastels.

Pastel pencils often come in metal boxes of twelve, twenty-four, or fifty colors, although they can also be bought individually.

A. Box of fifteen colors for painting any subject.

B. Special range for painting landscapes, containing predominantly greens and umber.

C. Special range for painting figures, containing creams, pinks, reds, and browns.

Color Ranges

Color pastels are usually grouped in color ranges chosen specifically for painting particular themes. Some ranges are designed for painting landscapes and primarily include greens and umber; ranges for seascapes are predominantly blue and green. For painting human figures the range includes pinks, flesh colors, creams, browns, and oranges. These colors are ideal for portraiture and often include a blue stick for the model's eyes or hair.

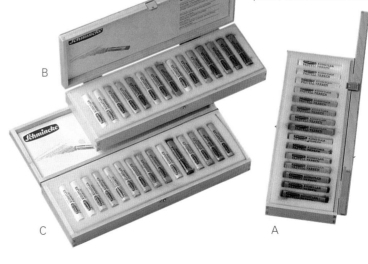

B

C

A

Other Materials

Although pastel painting is a simple technique that applies color directly onto paper, there are numerous complementary tools that can facilitate and enrich your work.

Drawing and Erasing

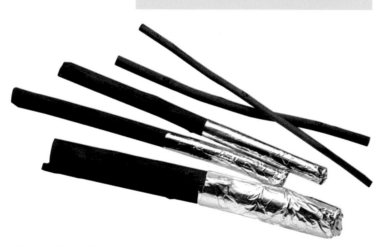

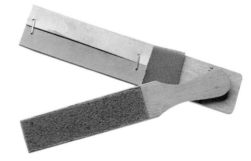

Sharpeners. Sharpeners are small sandpaper boards on which you can sharpen color pastels to paint fine lines. Some include a small sponge to remove any excess color shavings from the stick. See "How To Use Pastels," pages 16, 17.

Charcoal Pencils. These are used for sketching and drawing preliminary outlines before adding color. Charcoal pencils are simply pieces of carbonized wood. The soot comes off easily, making them ideal for drawing. Charcoal pencil marks can be erased easily with a cloth but will never totally disappear. For this reason, we suggest applying fixative to your charcoal work before you paint to prevent it from soiling the colors you will apply to it. You will find charcoal pencils with different thicknesses in art supply stores. The size you choose depends on the size of your work. If you are working in a small format, a thinner pencil will be easier to use. See "Drawing with One Color," pages 26–29.

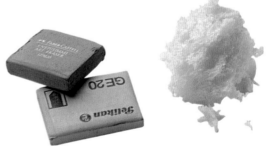

Soft Erasers and Crumbled Bread. Pastel paint can be removed from the paper's surface by erasing it with a very soft eraser that will not ruin the paper. Crumbled fresh bread (not the crust) is another good resource that serves the same purpose.

Cutting and Fixing

Scissors and Utility Knives. These are used to cut your paper to a desired size. It's a good idea to keep these on hand as there may be times when you wish to paint using a smaller format.

Rulers. Rulers are used for drawing straight lines, measuring the paper and guiding the knife when cutting it.

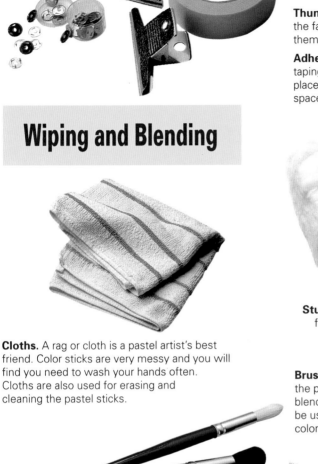

Easel Clips. Clips are a clean, quick, and useful way to attach your paper to the board without ruining it. Keep in mind that the paper should be almost as big as the board. If not, you will be able to attach one side only. If this is the case, it's possible that the paper will move or wrinkle with vigorous strokes.

Thumbtacks. Tacks are small, inexpensive, and portable. Despite the fact that they leave little holes in the paper, many artists use them to secure their paper to the support.

Adhesive Tape. Although tape can remove the top layer of paper, taping is a good way to secure your paper because it holds it in place at all points. Taping is a good idea because it gives you the space to work freely and paint with energy.

Wiping and Blending

Cloths. A rag or cloth is a pastel artist's best friend. Color sticks are very messy and you will find you need to wash your hands often. Cloths are also used for erasing and cleaning the pastel sticks.

Stumps, Cotton, and Cotton Swabs. These are used essentially for blending colors and gradating tones. However, they can also be used for painting and removing excess pigment. See "Blending Pastels," pages 20 and 21.

Brushes. Brushes are often used for removing the pastel dust from the paper. In addition to cleaning, brushes are also used for softly blending the colors and making corrections. Moreover, brushes can be used to dilute pastel color with water to create special effects or color a background. See "Tricks of the Trade," pages 48–53.

Pastel Pencils. In addition to sketching, pastel pencils are used to paint details that cannot be done with thicker sticks.

Hard Pastels or Pencils. Chalk and Conté sticks are classified as hard pastels. They come in stick or pencil form and are used for sketching and drawing. Their sharp points can be used for painting fine lines or details.

Fixatives. Fixatives are essential in pastel painting. If you do not fix your work when you have finished, the color will come off little by little through moving and handling. Furthermore, fixative is very useful because it will prevent the colors in your painting from mixing. It can be bought in bottles or, more practically, as an aerosol. See "Tricks of the Trade," pages 48–53.

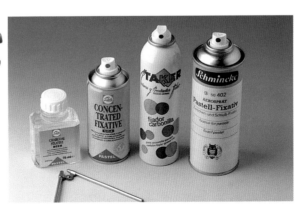

How to Use Pastels

Although pastel is a direct technique that does not require brushes, palettes, or solvents, it can be a mystery to those who have no experience with it. In this chapter we will teach you the basic uses of pastel.

Holding the Stick and Painting

To begin, hold the stick between your fingers as if it were a piece of chalk. Place the point on the paper and apply pressure as you move it across the page. The harder you press, the more color will come off the stick onto the page. You can draw thick or thin lines depending on the angle at which you hold the stick.

By holding the stick at a sharp angle to the paper and using its edge, you can draw lines thin enough to paint small details.

If you position the stick perpendicular to the paper you will draw a line as thick as the stick.

You can paint with the entire length of the stick to create very thick lines or to quickly paint large areas.

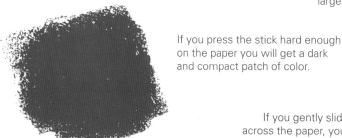

If you press the stick hard enough on the paper you will get a dark and compact patch of color.

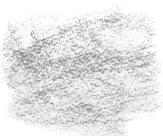

If you gently slide the stick across the paper, you will bring out the paper's texture.

Experimenting with pressure is a standard practice in pastel. In this example, the stick is applied with more pressure at first and gently less as it curves.

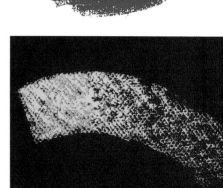

An eraser can be used to paint as well; by removing color, you can draw.

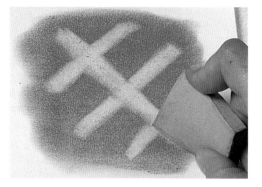

Sharpening Your Sticks

With use, sticks typically become rounded on the edges. At times the artist will need a sharper edge, like that found on a new stick in order to paint details. To do this with an older stick, you use a sharpener. This utensil is simply a piece of wood with sandpaper attached to it. Occasionally sharpeners come with a sponge for cleaning up the color shavings.

One disadvantage to sharpening your sticks is that it wastes much of their color. For this reason, many artists save the excess shavings for later use.

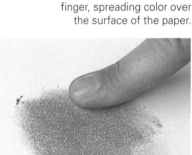

To sharpen a stick, rub one end of it across the sharpener's surface.

With a brush you can collect shavings and store them in a container. If you mix color shavings together, you can create interesting neutral colors for painting backgrounds.

You do not need to throw out color shavings; they can be put to good use by directly painting with your finger. Just rub your fingertip in the shavings and they will adhere to your skin.

You can paint easily with your finger, spreading color over the surface of the paper.

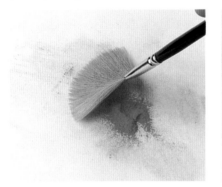

Cleaning Your Sticks

The pigment in pastel sticks spreads easily and will inevitably make your hands, the storage box, and the other sticks quite dirty. There are two ways to keep your sticks clean, illustrated below.

You can clean the sticks with a cloth after each painting session or whenever it's necessary to use a pure color.

A good system for eliminating color particle stains from other sticks is to put your sticks in a box with rice. If the sticks are very dirty, gently shake the container so that the rice rubs against them and removes the color particles.

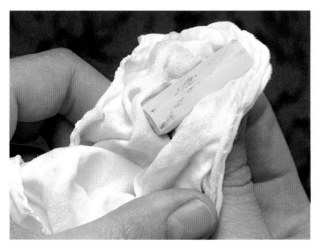

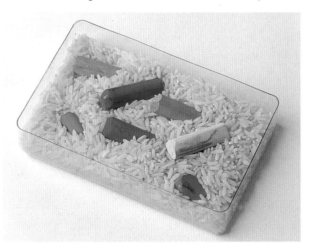

Gallery of Stains

Despite being little more than a stick of dry pigment, pastel holds many possibilities for expression. You can use lines to create patterns or blend colors, then stain them softly and imprecisely.

On a green background that has been smeared with a finger, other colors have been applied in small stains to create this vibrant color sensation.

Optical mixes can be very interesting. In this example, reddish green lines have been hatched on a blended blue stain.

Painting lines of different thicknesses can enhance your work's expression. Here we see a burnt umber background drawn with the stick's full length. Green lines overlap the black outline.

When pastels are applied to coarse-grained paper, they bring out the paper's texture.

When pastels are blended, their appearance can be completely altered to produce a light and porous effect.

Like watercolor paints, pastels can be diluted/mixed with water to paint backgrounds or create effects. See "Tricks of the Trade," pages 48–53.

You can cover an area with color to form a framework of vigorous and expressive strokes.

The combination of lines and blends is another pastel technique that allows you to create images such as this one, which resembles a waterfall.

Blending Pastels

Pastels are concentrated sticks of dry pigment that can be used to paint lines or, if they are blended, to paint subtle gradations of color.

Blending Colors

Blending colors means to spread them once they have been applied to the paper's surface. By doing this, your colors last longer and you can obtain uniform or gradated stains. There are various tools that can be used to blend. However, the most commonly used utensil is the artist's own fingertip.

A cotton ball is also a good tool for blending, especially when working with large formats.

The stump is one of the most common tools for spreading pastels. However, it has the disadvantage of getting dirty easily and it cannot be cleaned, so it will dirty colors that are applied in a pure form.

A fan-shaped brush or any other brush with soft hairs can be used to blend colors, but you should be careful not to loosen too much pigment from the paper's surface with the brush's head.

REMEMBER . . .

■ You can blend a color to obtain an opaque stain or to gradate a color until it is almost transparent.

■ To successfully fuse two colors you must apply the lighter one to the darker.

Gradating Two Colors

Blending can also be performed to softly combine two colors. When you blend colors in this way, keep in mind that when two colors are mixed they always create a third. To obtain a soft blend, it's important that the three tones fuse harmoniously. Remember to apply lighter colors over darker ones.

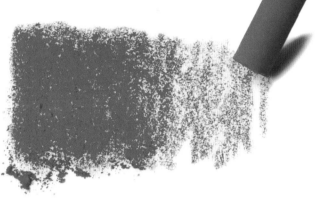

1. Apply scarlet, gradating the tone little by little.

2. Paint with yellow and have it cover the scarlet in the area you wish to blend.

3. With your finger, begin to blend the colors from top to bottom.

4. In the final result you can clearly see the orange produced by the mixture in the combined area. If you want to create more subtle gradations, repeat the process blending the lighter color over the darker one.

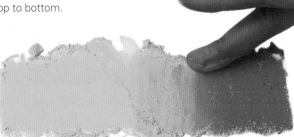

Pastel Stains

The pigment in pastel sticks comes off easily and if you blend with your hands you will see that they get dirty easily. In order to keep your hands clean, keep a moist cloth nearby to wipe your fingertips.

The result of holding a paperless pastel stick will be dirty fingers. If you blend colors with your fingers, they will get even dirtier.

A moist cloth or rag will allow you to clean your hands and fingers quickly and to continue with clean colors.

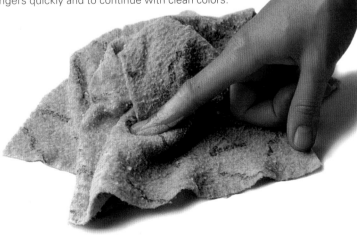

Mixing Colors

It is not easy to mix pastels. A dry art medium, pastels are less malleable and versatile than a wet medium. Even so, mixing pastel colors is a common practice since the artist cannot have every color in his box.

Mixing Paints

Pastel paint is mixed directly on the paper. It can be done by physically mixing the paint together or by superimposing one color onto another. The latter method is known as an optical mix. To physically mix two colors you must apply one color onto another and blend them with a finger, paper stump, or any other utensil. If you wish to mix two colors on the paper you can follow this simple procedure:

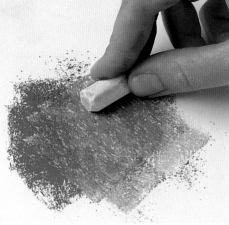

1. Apply one color to another, as in this case where yellow is applied on blue.

2. Mix them with your fingers and you will get green.

4. Yellow has been blended with green to obtain a lighter green.

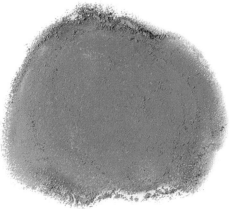

3. If you wish to change the intensity of the green, simply apply one of the two colors on it.

Optical Mixes

Optical mixes are achieved by drawing lines of one color on top of another in such a way that the base color is seen through the lines of the superimposed color. The color is mixed in our eyes rather than on the paper. The result produced is vibrant and undefined, and generally creates a sensation of depth.

Optical mixes are a way to significantly enrich your work and strengthen its expression of color.

The red in this blend allows the black base color to remain visible, creating a darker red.

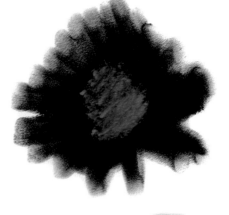

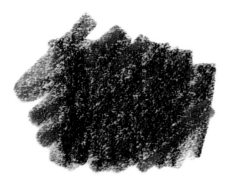

This mixture of red and black produces a brown.

Various glazes of individual colors create special tones and can produce a dynamic sensation.

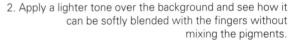

Making a grid or pattern on top of a background color can also produce an optical mix.

Preventing Colors from Mixing

When painting with pastels you often superimpose new colors and tones over the background colors. Occasionally you will want these colors to mix softly. However, there will be times when the purity of tones needs to be maintained, especially when working with light colors. To avoid creating unwanted mixes you simply fix the background with fixative.

1. After painting a color, fix it.

2. Apply a lighter tone over the background and see how it can be softly blended with the fingers without mixing the pigments.

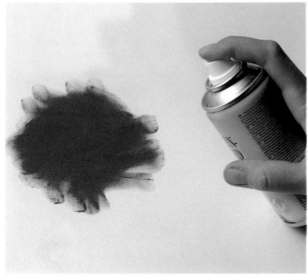

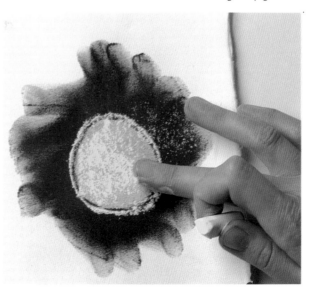

The Base Color

It's common in pastel painting to use colored as well as white and cream papers. The tone of colored paper serves as the background or base color and becomes another element of composition in your picture.

The Importance of a Base Color

Although pastel paint is good for covering large areas, it is common to let the color of the paper remain visible in the painting, either by leaving areas unpainted or by dilut-ing the tones of the pastels in order to obtain transparencies. Thus, the artist can take advantage of the base color to create contrast or avoid painting intermediary tones. The base color is fundamental in the resulting painting.

Note how the image shown here changes according to its background color.

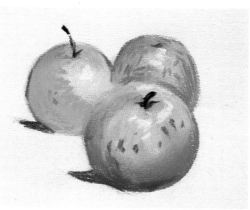

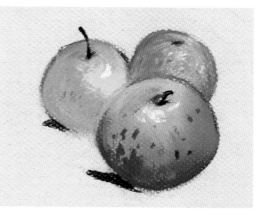

On a cream base the color mass is more harmonious and produces a softer contrast. Because of the paper's rough grain, its tone breathes gently through the colors.

On a white base there is a strong contrast of color that could be annoying since the intensity of the white inhibits the luminosity of the apples. For this reason, the artist will often cover the base with a blend of soft tones. To paint the apples, it is essential to completely cover the space they occupy with color

This dark paper has a special surface similar to fine sandpaper. The same effect occurs with black paper as that produced by white, only inversely: there is very strong contrast and the apple's luminosity is over-enhanced.

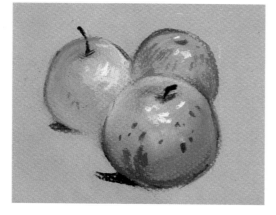

An ocher such as this is perhaps the most ideal base color in terms of composition. Due to the texture of the paper, the base color will remain visible through the superimposed tones, thus suggesting the intermediary tones.

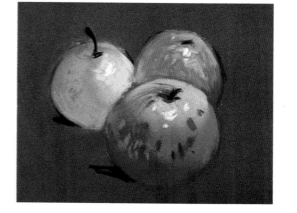

The Paper's Color As an Element of Composition

We have seen how a base color can influence the result and the artist's working method. However, it's possible that the previous examples do not clearly demonstrate the paper's function as a fundamental element of composition until you sit down to paint. The three following examples should help you better understand.

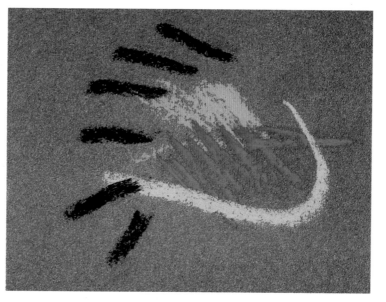

This abstract painting was done on sandpaper. Its color is fundamental to the painting's composition since it is seen between the lines of pastel and, as the base color, it performs the same function that another pastel color would.

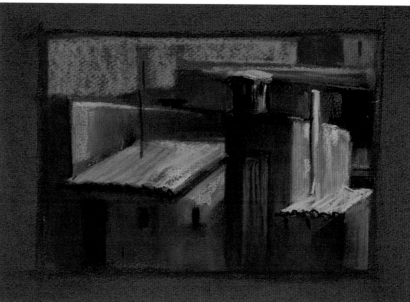

In this painting of roofs composed on dark paper, the artist did not have to cover the paper's surface completely. The paper is effective because it softly blends the colors and produces distinctive tones.

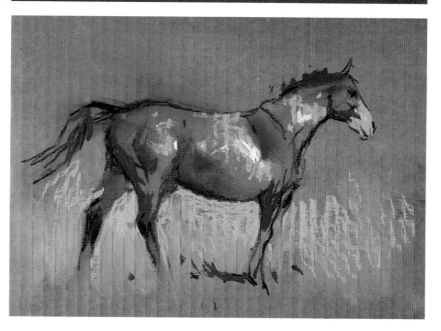

Pieces of cardboard have an appealing color and can be ideal for painting certain themes. The same horse produced on a lighter or darker background would come out entirely different for two reasons: the mood that the paper's color creates as a base color, and the role played by the base color in lending the horse color. Here the color of the cardboard functions as an intermediate color around the horse's neck and hooves.

Drawing

Drawing is the cornerstone of pastel painting. The shape of the sticks and the type of pigments used are most appropriate for producing the lines that in turn create the imaes in this medium.

The Importance of Drawing

Although each artist freely chooses his own style, the habitual use of sticks and paper makes pastel painting a close cousin to drawing. In effect, working in pastel relies on drawing to create pictures.

To be successful at pastel painting, it is essential to know how to draw and develop a degree of mastery over it.

If you still do not have experience drawing now is a good time to start practicing. The results can be as interesting as painting, not to mention the fact that it's much easier and less expensive.

To begin drawing outlines and sketches of the motifs you wish to paint, you need a sketchbook and a charcoal pencil. Although it seems a nuisance to draw a subject before painting it, we advise you to do so. Through practice, you will develop confidence in using your hands. Furthermore, don't forget that pastel is a technique that allows for few corrections. You should become adept at drawing. Erase and start over when necessary; once you have applied colors, it will be more difficult to change the work's fundamental structures.

When you have become familiar with drawing and sketching outlines, you will be able to add references of color to your work that you can refer to later in your studio.

In addition to charcoal pencils, sketches can be made with a pencil, or with pastels.

Sketchbooks are very practical because they are easy to carry and they are sturdy enough for sketching just about anywhere.

REMEMBER . . .

■ The technique of pastel painting is closely related to sketching, therefore mastering sketching will guarantee success with pastels.

■ It's advisable to do practice drawings, sketching the subject before venturing into painting. This will require you to study the form's shape and volume closely.

■ The number of preliminary drawings you can do is unlimited. The more work you put into drawing, the more advanced your mastery of pastels will be.

When sketching a subject, try to study it from different angles to better understand its form.

A sketch can be as authentic as a painting.

It could be interesting to sketch your subject in color. You can work comfortably in your studio later by having such a strong reminder of the original colors. Observe the simplicity and freshness of this sketch of a duck. With two stains of color the artist has perfectly recreated its appearance.

Like pastel, charcoal pencil must be fixed to the paper in order to prevent your sketches from being smeared while carrying your sketchbook around.

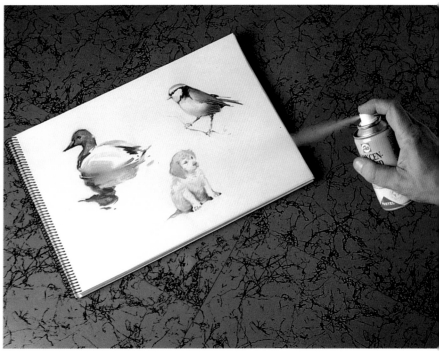

One Color

The best way to familiarize yourself with the techniques of pastel is to begin painting with only one color. In this way you will learn to hold the stick and experiment by applying different degrees of pressure and using different colors. This type of exercise is essential for developing an understanding of tonal values. Without the influence of other colors, the artist must convey a sense of shape and volume through the tonal intensity of the color he is using.

To do this exercise using one color, we have chosen black because of the distinct tonal intensities that this color can produce.

Painting with One Color

At times the division between what defines a drawing and what defines a painting is unclear. Doing monochromatic painting is a fundamental exercise. The artist, being limited to interpreting the image with only one color, is required to rely on shadows and light. Further, he must work with the particular tones that this color can produce.

We have chosen a simple cloth as a subject. Despite its simplicity, its folds pose certain difficulties. By the final stage of the exercise, we will discover that even the most unassuming object can be pictorial.

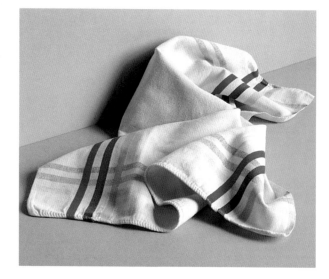

1. We begin by sketching an outline of the cloth's form.

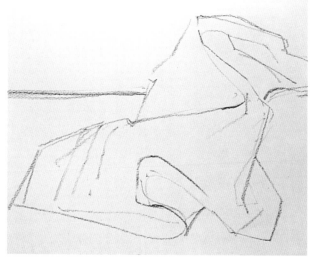

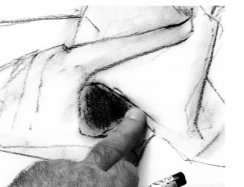

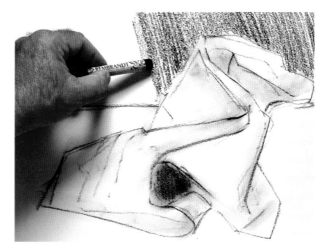

3. The background is essential for enhancing the cloth's true tonal intensity. For this reason it's important to paint the background now, not at a later stage.

2. Continue by painting light and shadow with corresponding tones. Observe how the primary fold is softly darkened by simply spreading the color of the lines. A much darker tone is used for the shadow in the fold. First, color is applied then blended with a finger.

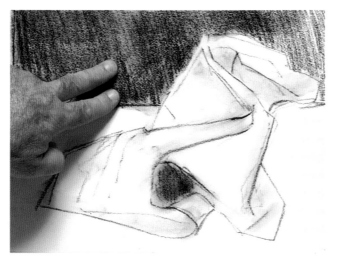

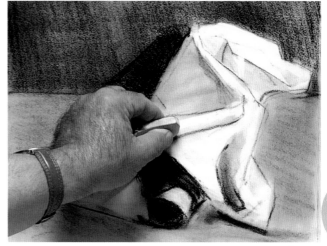

5. The background color has given us a reference point to darken the cloth's shadows. Some parts need more light. This can be accomplished by revealing the white of the paper with an eraser.

4. After applying the background color with parallel strokes, blend it with your fingers or a cloth. Now that we have the tonal basis on which to work, we simply need to adjust the shadows and polish the volumes.

7. In the exercise we have just finished, notice the tonal corrections we have made in comparison to the first steps. Observe the detail of the highlights created with the eraser. The contrast between the brightest parts and the darkest parts are those that create a feeling of depth.

6. Now we will paint the cloth's stripes and work on details in the shadows and points of light.

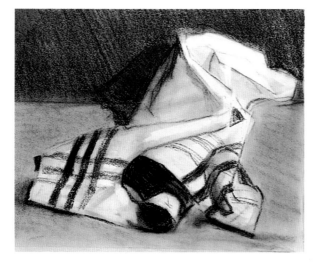

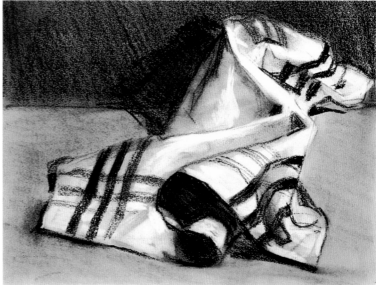

Two Colors

In order not to turn the adventure of painting into something frustrating, it's important to introduce the use of color step by step. Therefore, after having worked with one color, now is a good time to begin exercises using two.

Painting a Subject with Two Colors

To be sure, painting with two colors is still laying a foundation for constructing an image by applying different colors. However, working with two shades and experimenting with color contrast is an introduction to what it will be like working with many colors at a later stage. In this way you will begin to familiarize yourself with mixing colors and the complexities involved in it.

The colors we will use in this exercise are ocher, yellow, and black.

The subject we have chosen is a simple still life of a hammer and file. Since the color of the board on which these tools are placed is similar to theirs, we have decided to do a rendition of the subject on a white background.

1. Begin by drawing the forms, putting them on the paper and indicating the placement of the image.

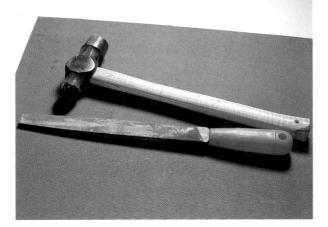

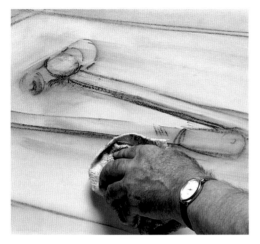

2. Begin by resolving tonal values. At this stage the artist changes the background, paints the gray area with ocher and dirties the white area of the paper by softly wiping the drawing.

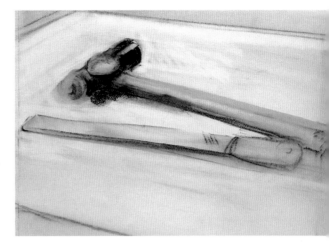

3. We have cleaned the surface of the paper with an eraser to bring out some of the highlights from the dirty white area. Next we begin to paint the hammer.

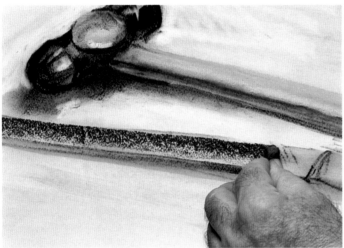

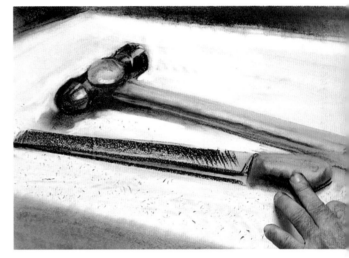

4. To bring out the file's rough surface it's enough to gently slide the pastel across the file's area, allowing the paper's surface texture to be revealed.

5. On the ocher background we have blended some black to obtain an intermediary tone between the two colors. The shadow on the file's handle is painted by blending black over the ocher of the wood.

6. As we finish the exercise, take note of several final points. The shadows have been touched up to make them darker and more highlights have been brought out with an eraser. The white background has been covered with a subtle layer of ocher to give the piece more continuity.

REMEMBER . . .

■ Learning to paint with pastels requires time and dedication. If you find your first exercises are terrible, don't despair; this is natural! Through practice you will learn to paint how you like.

■ It's a good idea to begin with simple subjects. This will make your work easier and help you gain confidence.

■ Painting is interpretation. You are free to construct the subject's image in a way that is agreeable to you.

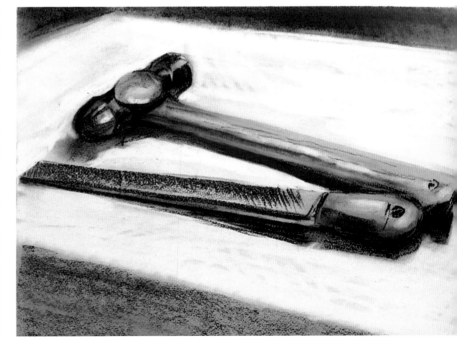

Three Colors

By increasing the range of colors you use you also increase the complexity of your work. To continue the gradual learning process of pastel techniques, we advise you to begin working with three colors only after you have practiced using two.

The three colors we will be using in this exercise are vermilion, green, and black.

Painting with Three Colors

Painting with three colors creates new challenges and increases the complexities of pastel painting. In the previous chapter we came across problems that were easier to resolve because the intensity of ocher is lighter than that of black. In this chapter we will complete an exercise using colors that are more similar. You will find that when attempting to paint a specific tone, you will need to choose the most appropriate pastel color.

A simple plate of fish and mussels will make a good subject for this exercise.

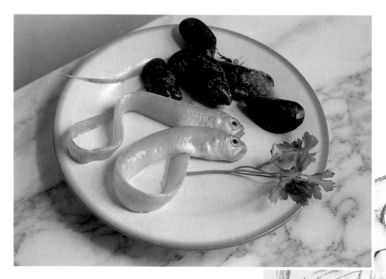

1. We have begun with a drawing of the subject to frame the image and position the bodies within the space of the paper. Since the subject contains some very light areas, excess pencil dust has been swept away with a fan brush to keep the paper from getting dirty.

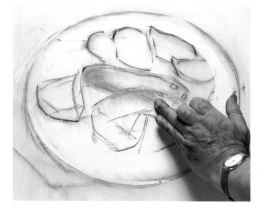

2. To begin painting, we have taken the vermilion pastel and, after drawing a few lines, have blended it with a finger.

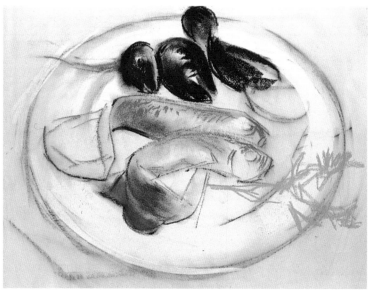

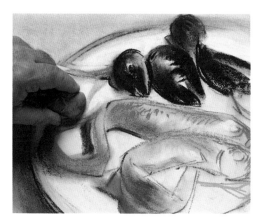

3. We continue by using the black to paint the mussels, making sure not to go over the white highlights with the stick. In this way we use the white of the paper as the lightest color in our limited palette.

4. In the previous step we painted the parsley and brought out the schematic texture of the fish with small points. Notice how the artist uses the eraser to emphasize a highlight of the plate.

5. At this stage, the exercise is almost finished. All that remains is to correct the intensity of some of the shadows and to paint in details. Take note of the table's green tones; the artist has chosen green to play with the contrast produced by the red of the fish.

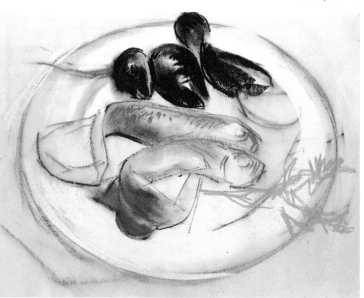

6. We have finished painting the details of the fish and brought out some highlights in their bodies with the help of an eraser. The parsley's shadow has been intensified, as have those of the fish and the plate. Observe the soft touch of red in the mussels and the green in their shadow. Details such as these contribute to the unity of the work.

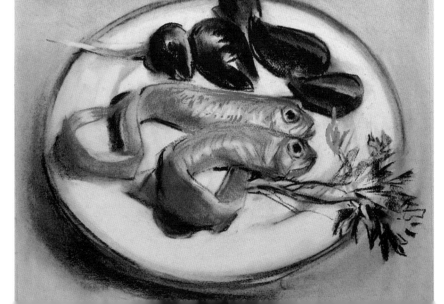

Palette Suggestions

Pastel artists usually rely on a large palette because pastel, being a dry medium, does not mix easily. However, to begin, a range of fifteen colors is sufficient to master the technique and develop confidence.

Fifteen Colors

You can buy pastel ranges with an astounding number of colors. Because pastels are dry paints and are difficult to mix, professional pastel painters must rely on a large number of colors.

As a beginner, however, we advise you to start with a small range of just fifteen colors. This will allow you to paint almost any subject while staying focused on familiarizing yourself with basic techniques and learning to use pastel with confidence and ease. Later on, it will be a good idea for you to increase your range by buying colors that facilitate your work, thereby creating your own color range.

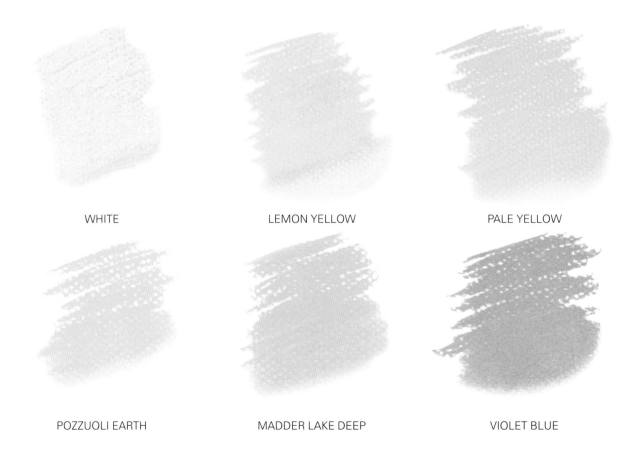

WHITE

LEMON YELLOW

PALE YELLOW

POZZUOLI EARTH

MADDER LAKE DEEP

VIOLET BLUE

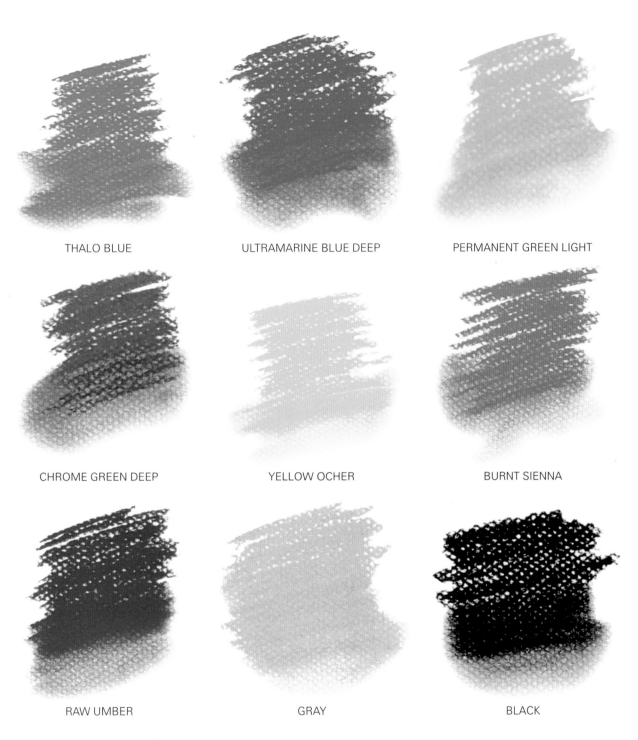

THALO BLUE

ULTRAMARINE BLUE DEEP

PERMANENT GREEN LIGHT

CHROME GREEN DEEP

YELLOW OCHER

BURNT SIENNA

RAW UMBER

GRAY

BLACK

It's important to remember that when painting with such a small range you will often have to mix colors in order to obtain other colors. Therefore, we advise you to test your colors before painting and establish the kinds of mixes you can create. Experiment with standard mixes as well as optical mixes. See "Mixing Paints and Preventing Color from Mixing," pages 22 and 23.

Professional pastel artists work with many color sticks in order to achieve in a direct way the shades they need. From this small range you can widen your palette with the colors you often mix as well as those you prefer to use.

Methods

Although every artist has his own individual method, there is a classical process for pastel painting that will facilitate your work and help you paint your first works successfully.

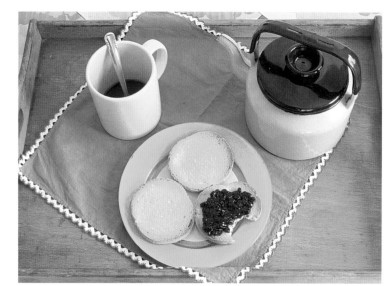

We will paint this breakfast tray following the classical process of pastel painting. If you have already practiced drawing, you will not find this subject too difficult. If, on the other hand, you have not achieved some mastery at drawing this might seem complicated. If this is the case, we advise you not to rush into this. Paint something less complex or practice part of this subject, like the plate and toast.

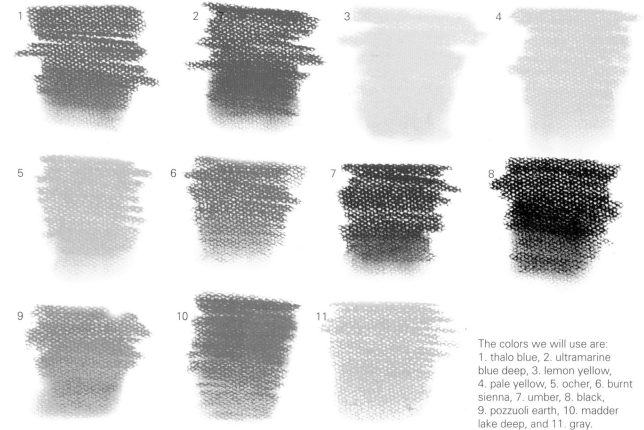

The colors we will use are:
1. thalo blue, 2. ultramarine blue deep, 3. lemon yellow, 4. pale yellow, 5. ocher, 6. burnt sienna, 7. umber, 8. black, 9. pozzuoli earth, 10. madder lake deep, and 11. gray.

Methods

Pastel technique is very closely related to that of drawing. Thus, the more practice and experience you have with the latter, the easier your task will be when you sit down to paint. It's essential to begin with an outline of the forms. Continue by applying color throughout your work, adding details one by one.

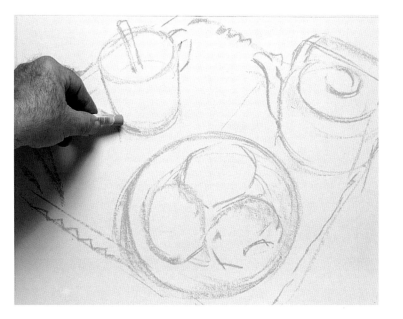

1. Begin drawing an outline of the subject on your paper. You may do this with a charcoal pencil, or as shown here, with a light pastel like gray. This will prevent the later colors from getting dirty.

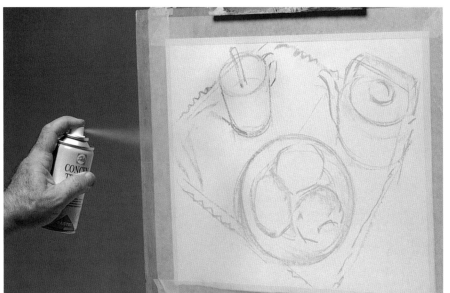

2. Use fixative to ensure that the first colors you use do not get the colors you will add dirty. Without fixative, this could happen even with the light gray used for your outline.

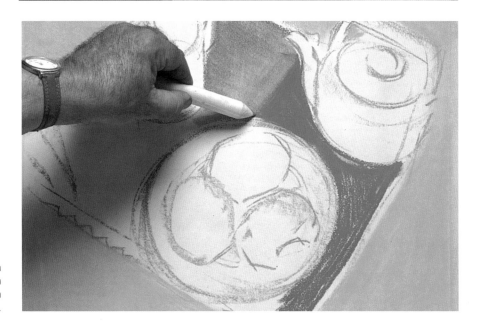

3. After painting the tray with yellow ocher, paint the napkin thalo blue and blend the colors in highlighted areas.

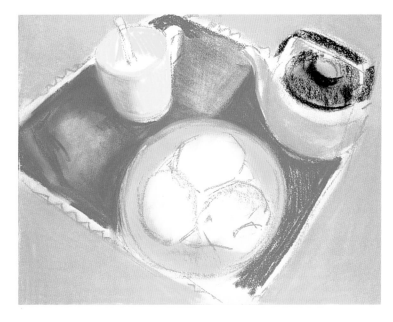

4. Continue by painting the plate and cup pale yellow; the teapot black and gray. Notice how adding a bit of pozzuoli earth to the plate and blending it into the yellow creates an orange tone.

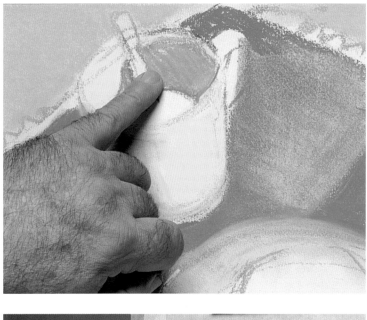

5. To obtain the dark tone in the cup's shadow you will need to mix colors. With a finger, blend a framework of pozzuoli earth over previously painted permanent green.

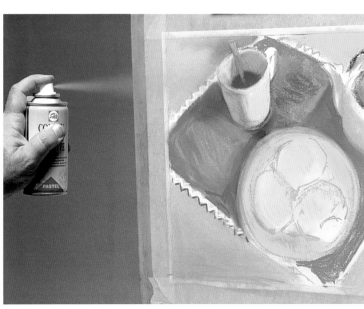

REMEMBER . . .

■ When beginning, we recommend you use small formats with medium grade paper weighing 180 grams (6.4 oz).

■ When practicing this technique, we advise you to begin by painting a subject that is not too difficult to draw.

■ It's important to fix your drawing before applying paint to avoid getting the colors dirty.

■ To obtain specific tones you must mix them on your paper, drawing them first, then blending.

■ We suggest you fix the colors during the process to protect the colors from inadvertent smearing.

■ The final points of shadow and light will give more depth to your work.

6. At this stage we have painted the entire surface of the paper, with each form resolved to a certain extent. Before you continue, apply fixative to your work to end the modeling process and to prevent your colors from getting dirty.

7. With the background colors fixed, you can create new blends without getting the other colors dirty. We will begin with the bread and teapot.

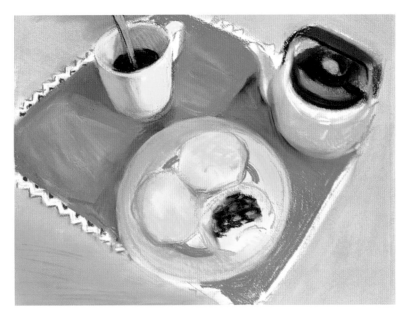

8. Continue to bring out the volume of the forms, adding light and dark tones over the previous blends. Notice the orange color in the plate made with a mix of pale yellow and pozzuoli earth in the upper right corner. It intensifies the napkin's tone.

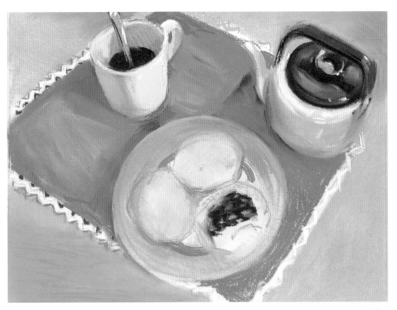

9. Finally we have painted the tray and its shadow, and have outlined the trim around the napkin. In comparison to the previous stage, you can see how the creation of the shadow on the front side of the tray gives the work considerable depth.

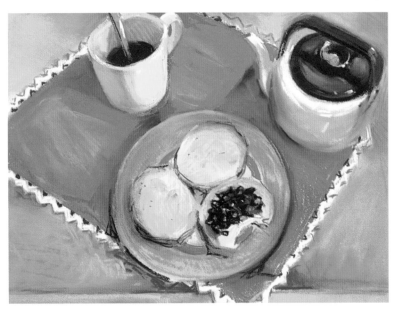

Blend-Painting

Blending is a common practice in pastel painting. This technique can be used as a complement to lines and stains or under color layers in the work, or it can be the primary focus.

Painting by Spreading Colors

Blending is nothing more than spreading colors on paper with a finger or other tool. The result is a compact film of paint that does not bring out the paper's texture or allow the underlying background color to remain visible unless the quantity of pastel used is minimal and the blend results in a transparent glaze. See "Blending Pastels," pages 20, 21.

We have chosen a still life of fruit as an attractive and colorful subject.

To paint this exercise we will use almost all the colors in our box: lemon yellow (1), pale yellow (2), puzzuoli earth (3), madder lake deep (4), yellow ocher (5), thalo blue (6), ultramarine blue deep (7), permanent green (8), chrome green deep (9), gray (10), raw umber (11), burnt sienna (12), white (13) and black (14).

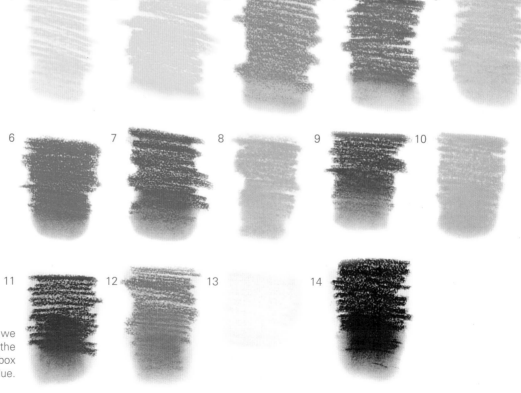

For this exercise we will use all of the colors in our box except violet blue.

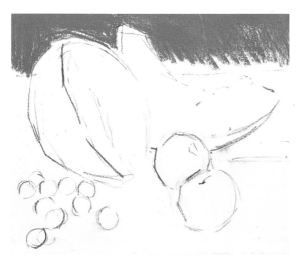

1. After sketching an outline with burnt umber, paint the upper background with ultramarine blue deep.

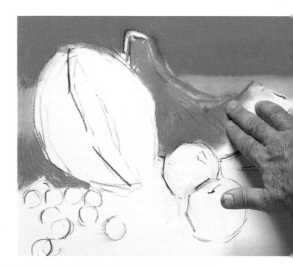

2. Blend the colors as you cover the paper. To paint the slice of watermelon mix pozzuoli earth and madder lake deep.

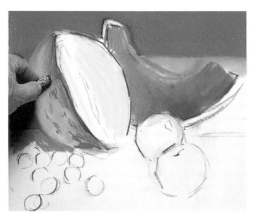

3. After blending the melon's rind, paint its irregularities with small green lines.

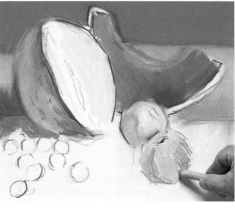

4. To bring out the peach's color, first paint its surface pale yellow with touches of pozzuoli earth and green.

5. Blend the peach's colors and they will come out orange.

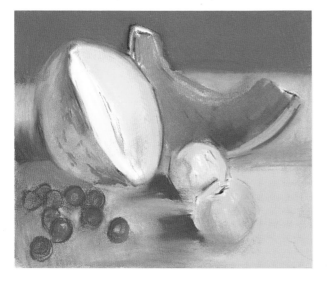

7. Compare this picture with the previous one. You can see how touching up and adding detail establishes the forms of the fruit and reinforces the volume without robbing the image of the diffuse and ethereal effect of blending.

6. After painting the rest of the work in this manner, all that remains is to touch up the shadows and paint the details.

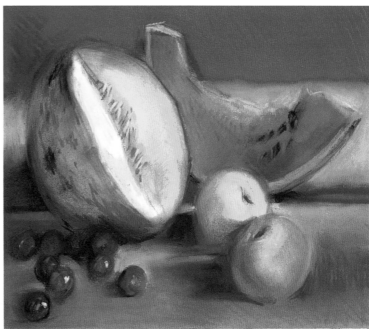

Draw-Painting

Whereas blending color on paper is achieved by stains or under color layers and results in a diffuse image, draw-painting is done by basing your work on lines to produce concrete and defined results.

Painting with Lines

D raw-painting with pastel is a technique that lies somewhere between pure drawing and pastel painting. Both techniques, therefore, are employed to create works in which details and lines are the cornerstones of the image.

A terrace has been chosen as the subject for this exercise.

Of the fifteen colors in your box, you will use thirteen: 1. lemon yellow, 2. pale yellow, 3. permanent green, 4. chrome green deep, 5. pozzuoli earth, 6. madder lake deep, 7. thalo blue, 8. ultramarine blue deep, 9. gray, 10. black, 11. ocher, 12. burnt sienna, and 13. raw umber.

1. Begin the drawing with a brown pastel pencil, then continue by painting the blinds with yellow and blue, which, when mixed, will produce a green.

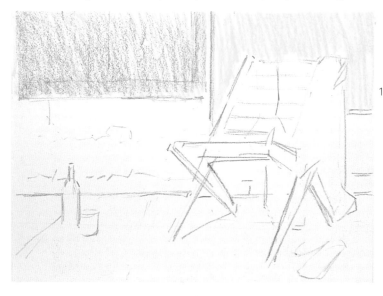

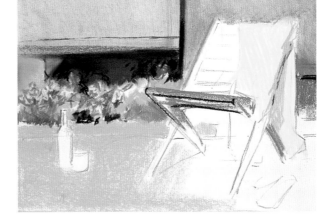

2. Next paint the large areas. At this point we are still working with blends that we will shape with lines later.

3. The blind's color has been blended with a paper stump to get this tone of green. Next paint the flowers on the ground and begin to outline the chair.

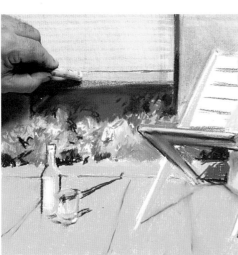

5. With yellow and blue pastel pencils, draw the fine lines of the blinds.

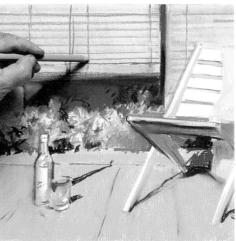

4. After painting the chair, outline the other forms using the sharpest edges of the pastels to draw lines.

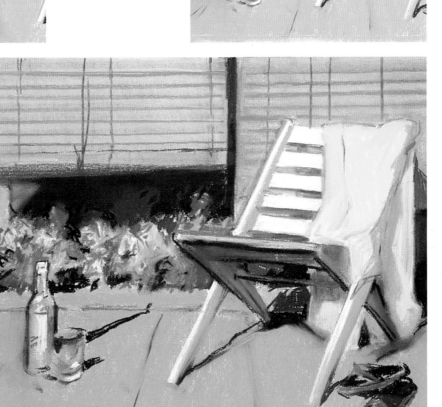

6. As you finish the exercise, you can see how the shapes have been created using only lines and how this technique allows you to paint the finest details.

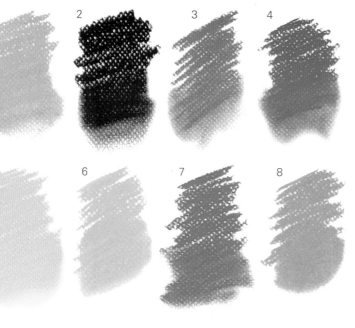

Paint-Painting

Pastel's versatility allows you to paint in a way that the result is nothing like a drawing, but contains all the elements of a painting done with brushes.

To Paint-Paint

The shape and form of pastel sticks favor drawing because they are ideal for working with lines. However, the versatility of these compact color sticks allows you to paint with pictorial results. To do this you can simply follow the guidelines used with, for example, oil painting, while using your pastel materials.

To paint the following exercise we have used:
1. gray, 2. black, 3. burnt sienna, 4. ultramarine blue deep, 5. yellow, 6. madder lake deep, 7. thalo blue, and 8. violet blue.

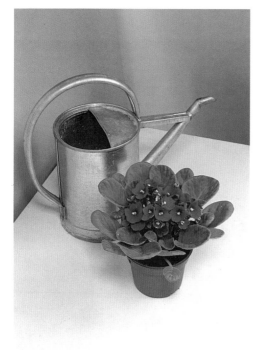

We have chosen a pot of violets and a watering can as the subject of this small still life.

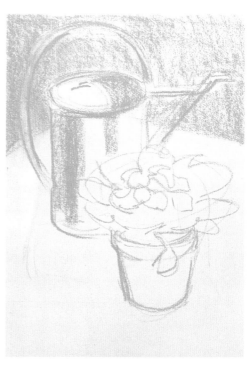

1. Begin by drawing an outline in gray. The light color will prevent the drawing's color and lines from being too evident later. Gray is also ideal for the background and parts of the watering can.

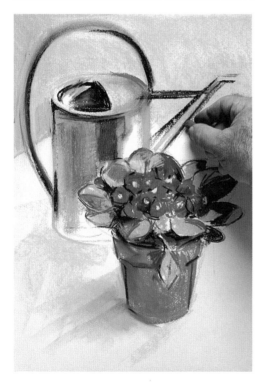

2. Continue by blending the background and begin working on the watering can. Notice how touches of black, ultramarine, and burnt sienna have been added to the gray and how the color has been "stretched" in a vertical direction to suggest reflection in the can.

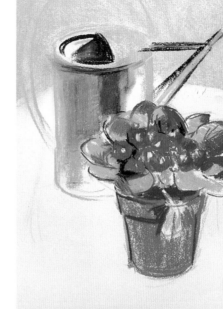

3. Paint the flowerpot with burnt sienna, the flowers with ultramarine and madder lake deep.

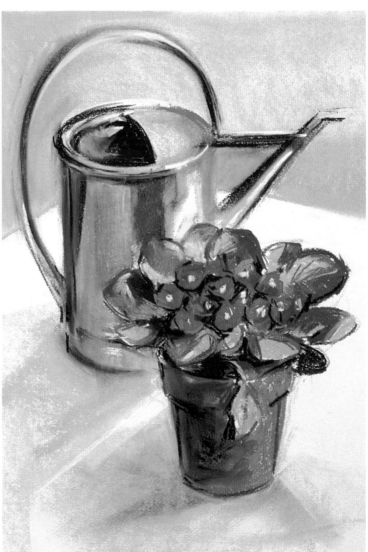

4. Once you have created the forms based on color blends, begin working on details. With regard to the can, outline its distinct form with thalo blue to emphasize the coldness of the metal. Bring out both objects' shadows on the table by creating vigorous lines of violet blue using the whole stick.

5. Notice in the final stage how the shadows on the table have been intensified with gray and some black. Small touches of yellow on the watering can and plant leaves add to the overall quality of coldness.

Painting with Water

The makeup of pastel paint is such that it can be easily diluted in water and applied as if it were watercolor. Once the first layers have dried, more color can be applied with water, or by using the dry techniques of pastel painting.

In this exercise we will use eleven colors from our box: 1. lemon yellow, 2. pale yellow, 3. white, 4. ocher, 5. ultramarine blue deep, 6. thalo blue, 7. madder lake deep, 8. pozzuoli earth, 9. gray, 10. raw umber, and 11. black.

Dissolving Pastels

Pastel sticks are composed of particles of pigment and binder that gives them their concentrated form. Their composition is similar to watercolor paint in that they are easily diluted in water and can be painted with in liquid form.

In order to paint with pastels in this manner, it is a good idea to use watercolor paper because it is well suited for absorbing moisture. It is important to fasten the paper to your board with adhesive tape since the moisture will warp it until it is dry.

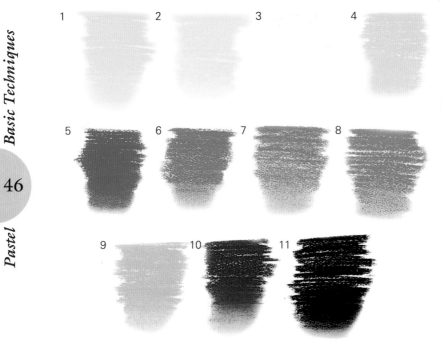

The subject we have chosen for this exercise is this small bunch of marbles on a bed of straw, which although realistically interpreted, forms an abstract image.

1. We begin by making an outline with charcoal pencil. Next we apply ocher and raw umber to color the straw.

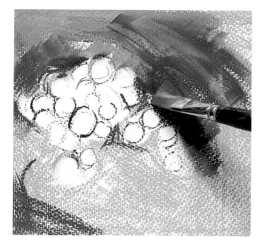

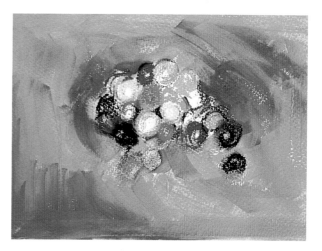

2. With a moistened brush, dissolve the pastel to obtain an effect that is similar to watercolor.

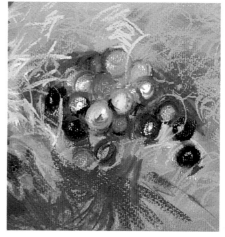

3. Once the background has been painted with water, directly paint the marbles with color sticks.

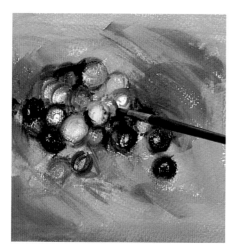

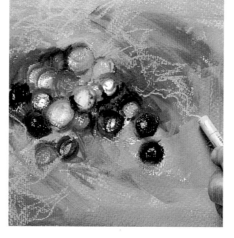

4. With a smaller brush, softly dissolve the colors of the marbles, playing with the pastel textures and the diluted colors.

5. When the color has dried, you can paint as usual with the sticks. The dissolved background has a perfect base color to bring out the straw's texture with fine lines of ocher.

6. Use raw umber and pozzuoli earth in the shadow areas to create the lines defining the straw.

7. In the final stage you can see how we have continued working on the straw's texture with the aforementioned colors and touches of yellow and white. Notice how the violet marble on the right has been changed by adding thalo blue to it. Also, notice how the marble's highlights have been brought out with touches of white.

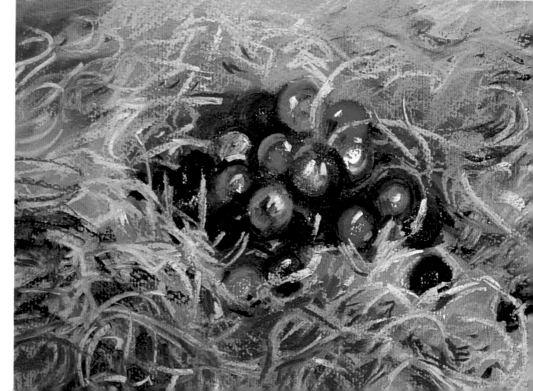

Tricks of the Trade

Within the pastel painting there are a number of techniques, or tricks of the trade, that will facilitate your work. These tricks will assist you in making corrections and strengthening your expressive capabilities and versatility with the medium.

Corrections

Pastel painting is not a technique that offers a large variety of options for making corrections. For the most part, your work should be painted without the intention of blotting the paper, and without mixing colors you do not wish to blend. However, many errors can be corrected several ways.

CLEANING THE PAPER

Sometimes when creating the first stains in a painting, you will notice the result is not what you intended. In order to start over without wasting the paper, you will have to remove the color particles as best as possible.

Most likely, after removing the excess pastel from the paper with a cloth, the remaining stains or tones will be suitable for the background of a new work. Thus, the paper can be considered "clean," depending on how you decide to use it.

1. You have already made several stains when you decide to paint a different subject. To avoid wasting the paper, you can try cleaning it.

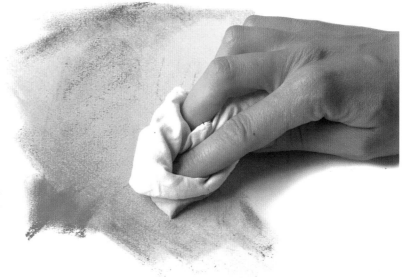

2. Because the colors have not been fixed to the paper with fixer, the pigment will come off easily when wiped with a cloth.

3. After removing the top layers of color, erase the remaining color with a soft eraser.

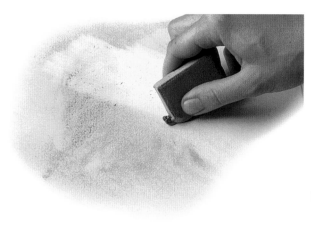

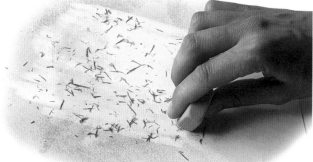

4. Other erasers and bread can be used as well.

5. As you can see, it is very difficult to completely remove the colors from the paper. This should not however, inhibit you from using the paper again. Let's start a new piece using dark colors.

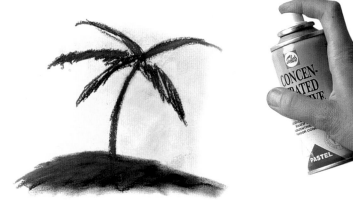

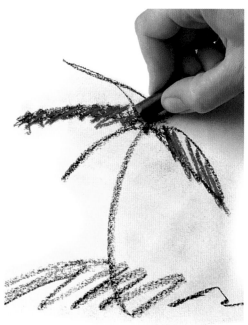

6. Before using lighter colors, fix what you have done so far to prevent the dark, top layers from dirtying the lighter base colors.

7. Once fixative has been applied, we can safely add a blue sky knowing it will not blend with the background colors.

REMEMBER . . .

■ Use fixative to prevent charcoal pencil, first blends, or a background from getting the colors dirty.

■ Once you have applied the fixative, you can no longer blend or remove the fixed colors.

CORRECTING WITH YOUR FINGERS

In addition to using them to blend or directly apply colors, your fingers can be used to remove color where you do not want it.

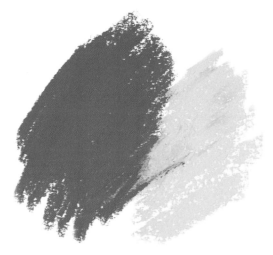

1. While drawing with violet, you have unintentionally painted in a yellow area.

2. With your finger, remove the violet.

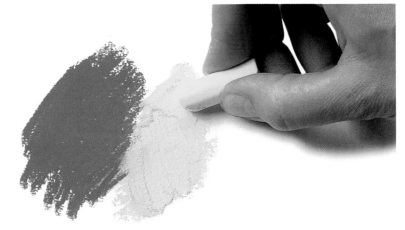

3. Even though the violet stained a little, you can easily draw over the correction with yellow.

CORRECTING WITH BRUSHES

Brushes are not often used to apply color. They are more frequently used to mix colors, clean paper, and make corrections. Brushes work like small brooms that sweep the pigment from the page. The harder the bristles, the better a brush will sweep.

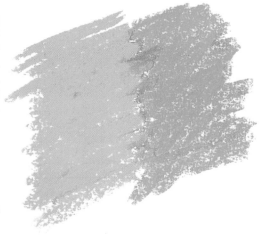

1. A green line has crossed into a field of orange and you have decided to correct it.

2. With a bristle brush, sweep the green line; you cannot avoid sweeping some orange as well.

3. In this case it is not necessary to reapply the orange. If you blend any leftover green with a finger, it will disappear.

COLORING THE PAPER

You would like to paint on a colored background but all that you have in the studio is a sketchbook of white paper. What do you do? All that is necessary to color a background is apply a color and blend it. However, if you prefer to conserve your pastels and obtain special effects, do the following:

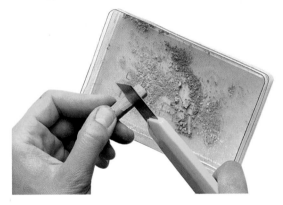

1. Keep all the shavings and dust you accumulate from painting and sharpening your sticks in a container. Add green pastel to this mix by gently shaving it with a knife; the shavings will have the consistency of dust.

2. Pick up your random mix with a cotton ball.

3. Apply the mix to paper and you will obtain an earth tone that is ideal for pastel painting. If you want to prevent the background from mixing with the colors you intend to use, you can fix the background before you begin to paint.

GLAZES

A glaze is nothing more than a fine layer of transparent color. Glazes are used to create atmosphere, special effects, or to mix colors. To make a glaze you simply apply a color and blend it. To apply one glaze over another or over a part of an already painted area of your picture, you must fix what you have done before applying the glaze to prevent the previously applied paint from being rubbed out.

2. Softly apply a little color.

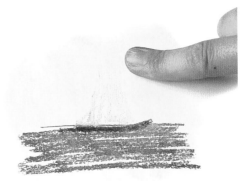

1. Fix the area of your painting that you wish to glaze.

3. Blend the painting with a finger. In this example, notice how the transparency of the glaze allows you to see the background stains softly changing color to create a warm atmosphere.

USING TAPE TO MASK

Painting urban landscapes or interior themes often requires you to paint many straight lines. This can be difficult to do. You can easily use masking tape to paint an area without ruining what you have already painted. When applying the tape be careful not to press down very hard, so that it will not pull the paint off when you remove it. Also, avoid leaving the tape on longer than a day as its glue could stay on the paper when you pull the tape off.

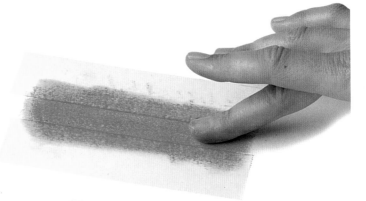

1. Softly apply tape to the paper and paint, blending the colors as you would normally.

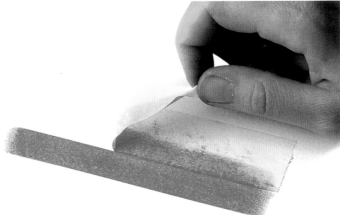

2. Carefully remove the tape and you will see how covered areas were left untouched by the newly applied paint. You can now paint these areas as you normally would.

Special Effects

Combining the basic materials of pastel with those of other mediums will allow you to create special effects that are well suited for bringing out textures or atmosphere, creating backgrounds, or creating abstract images.

EFFECTS WITH WATER

Because pastels are simply a combination of pigment and binder, they can be easily dissolved in water and used like watercolors. When dissolving pastel with water, it is best to use watercolor paper, even though pastel paper can support some moisture. The solution of water and pastel is generally used for backgrounds or for treating certain areas of a painting.

EFFECTS WITH WAX

Other resources you can use include wax crayons and candle wax, both of which adhere well to paper and retain pastel pigment.

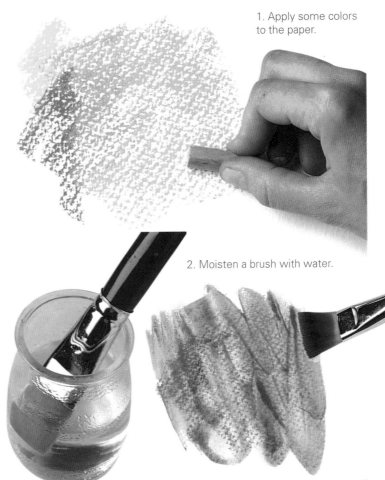

1. Apply some colors to the paper.

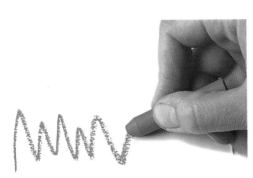

1. Draw a design with wax.

2. Moisten a brush with water.

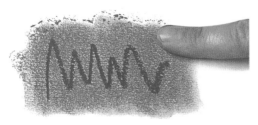

2. When you apply pastel, the wax will remain and intensify the particles of the pastel's color.

3. Upon contact with water, the particles will dissolve into liquid paint, similar to watercolor.

EFFECTS WITH TEXTURES

In the same way pastel reveals the paper's texture, it can also bring out other surface textures from underneath the paper. Such a surface must be rough enough to come through the paper when the pastel stick is rubbed against it.

We have placed the paper on a plastic surface with a rough texture. As you slide the pastel stick across the paper, it will perfectly outline the plastic's texture and create a suitable background for painting.

Skies

A clear sky may be one of the easiest things to paint. However, painting a sky that is filled with clouds bathed in sunlight can prove to be a difficult task. You will have to bring out the clouds' volume by experimenting with tones.

Painting a Sky with Clouds

Clouds have a light and airy appearance that can be difficult to convey. Furthermore, they are not simply white; their shapes and volumes produce shadows and tonal changes. Therefore, you must paint clouds with a range of colors.

When you set out to paint a sky, keep in mind that clouds change quite rapidly. So it's a good idea to sketch their form to avoid losing it.

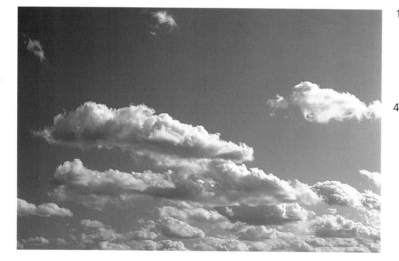

We will paint this sky containing an intricate group of clouds that are filled with warm and cool tones.

To paint this skyscape, we will use six colors from our box: 1. gray, 2. thalo blue, 3. black, 4. white, 5. ultramarine deep, and 6. lemon yellow.

1. After sketching the clouds' forms with gray, paint the sky with thalo blue.

2. Blend the colors you have applied so far with your fingers, maintaining the white form of the clouds.

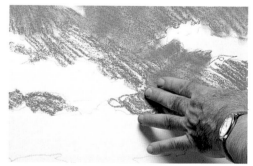

3. Begin to bring out the clouds' shadows, or volumes, with black.

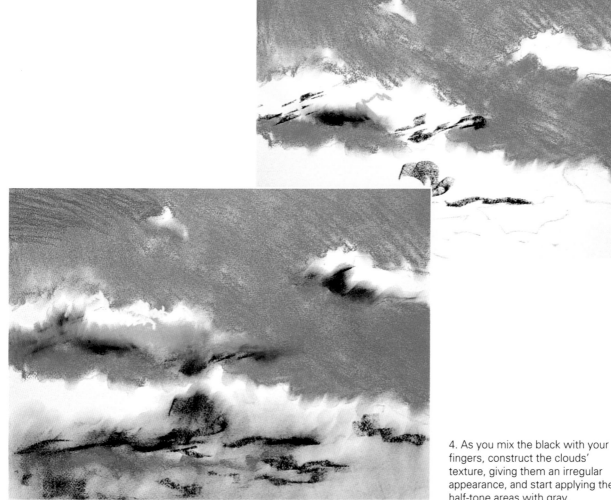

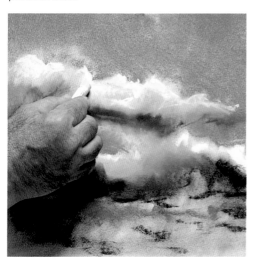

4. As you mix the black with your fingers, construct the clouds' texture, giving them an irregular appearance, and start applying the half-tone areas with gray.

6. To complete the painting, the lines have been completely blended. With a touch of white, we have created contrast between highlights and darks. Notice how using your fingertips is ideal for bringing out the clouds' spongy textures and ethereal forms.

5. Lemon yellow will help you put some touches of light and quality into the upper parts of the clouds. Notice how the sky has been touched up a little with ultramarine deep blended into the previous blue.

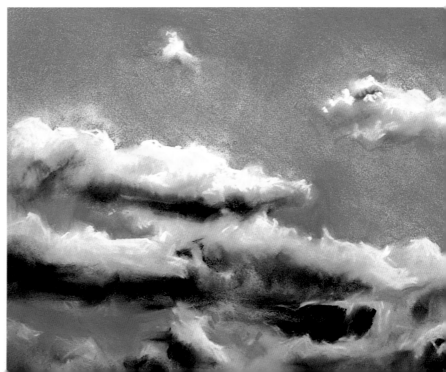

Water

Water is a mass of continuous movement that changes color in harmony with the changing light. For this reason, water is a motif that must be captured by expressing the spontaneity of its movement and the sparkles of light produced by its spray.

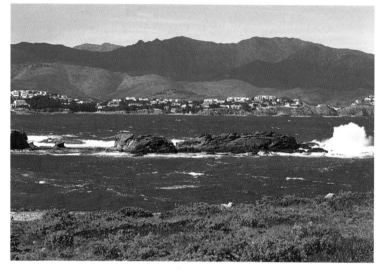

On a clear day with swells, the sea is covered in white lines of foam. It produces and helps suggest the movement of the waves.

Painting the Sea

Under the midday sun, the sea holds an attractive blue that changes tone and hue depending on the light and the distance from which you view it. You will have to create a series of distinct hues with subtle mixes, each of a similar nature. Seawater typically produces a great deal of foam when it crashes against rocks, or that manifests itself on the crest of waves. It is the contrast of light foam with the dark tones of the water and coast that make seascapes so desirable.

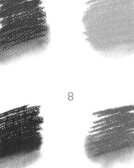

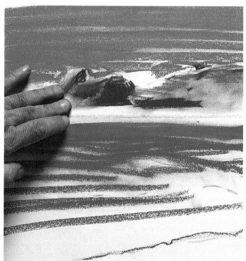

1. After drawing an outline, begin to paint the rocks. For the water, use thalo blue as a base and ultramarine deep on top. Blend the wave's tones on the white of the paper, which will help to suggest the foam.

In this exercise we will use ten colors, although to paint the water we will need just five: 1. thalo blue, 2. ultramarine deep, 3. chrome green deep, 4. gray, and 6. white. For the rocks and coastline: 7. raw umber, 8. burnt sienna, 9. permanent green, 5. black, and 10. ocher.

2. We have blended the background blues, keeping some areas clear to paint the foam. In these areas notice how the paper has become slightly dirty with yellow and the color of the sketch. To the foreground of the water, add a few lines of green to be mixed with blue later.

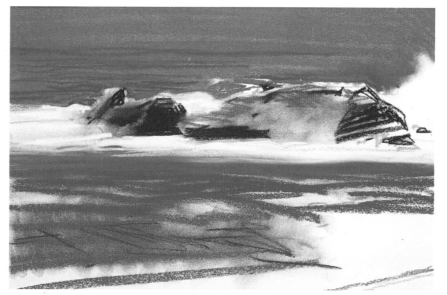

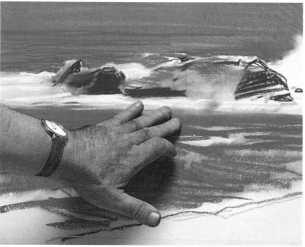

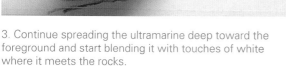

3. Continue spreading the ultramarine deep toward the foreground and start blending it with touches of white where it meets the rocks.

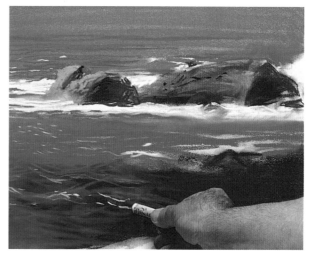

4. A couple of sinuous lines of ultramarine will help suggest the movement of water across and near the rocks. In the foreground we have added black and finally blended it to create a suggestive range of hues. You can paint over these tones with white to bring out the foam.

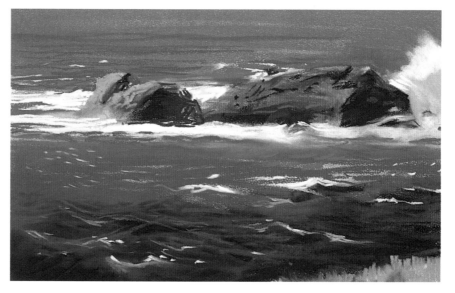

5. As you finish the painting, notice the presence of gray in the crashing wave to the right. It converts an otherwise flat stain into a voluminous one. Note as well that the direction of lines help to suggest the foam and the small sparkles of water.

Flesh Colors

Portraits and figures are two of the most popular themes in pastel painting. Human skin has a special quality and color that can be painted using a limited color range. The secret to success is in the combinations.

We will paint this model bathed in lateral lighting, which creates simple, defined shadows.

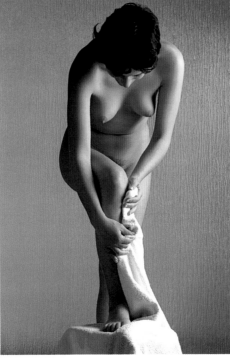

Painting the Skin

Sometimes the color of flesh is a combination of similar shades and tones, other times it is not. Color ranges made specifically for painting figures can be bought in art supply stores. However, it is possible to bring out skin tones with a small range that allows us to construct the necessary tones through mixing.

One of the main techniques of figure painting is to paint the body with warm tones and the shadows with cool. In this way, the contrasts you create strengthen the volume and freshness of the skin.

1. We have done a drawing with a neutral tone pastel pencil. Begin to paint the shadows on the left with madder lake deep and blend it with a finger.

The paints we will use in this exercise are: 1. madder lake deep, 2. permanent green, 3. black, 4. ultramarine deep, 5. pale yellow, 6. ocher, 7. burnt sienna, 8. raw umber, and 9. white.

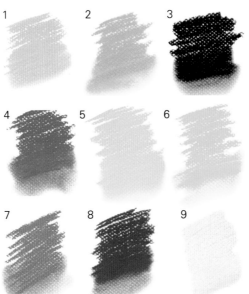

2. We have added permanent green to the shadows, creating a contrast of warm and cool tones. The hair is painted with blue and black.

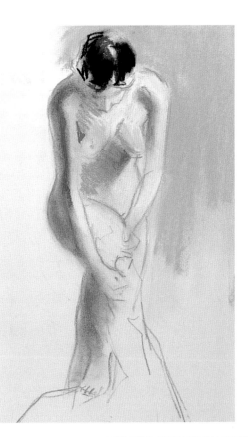

3. Next we apply the colors that will make up the skin tones. In light areas we will use yellow. Notice how we have begun painting the background gray in order to obtain the correct color tones because the white of the paper tends to be misleading.

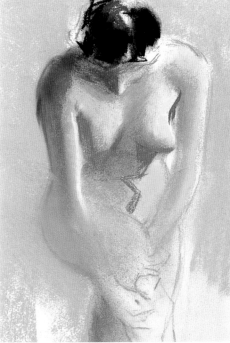

4. Add a little ocher to the yellow to deepen it. Now begin to blend the colors, softly merging them at their limits.

5. With the help of cotton we bring out the light in the small areas where fingers do not fit, adding touches of white to the lightest highlights.

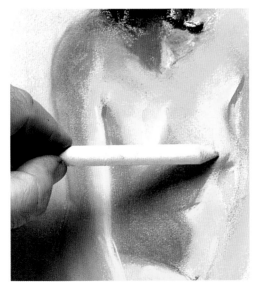

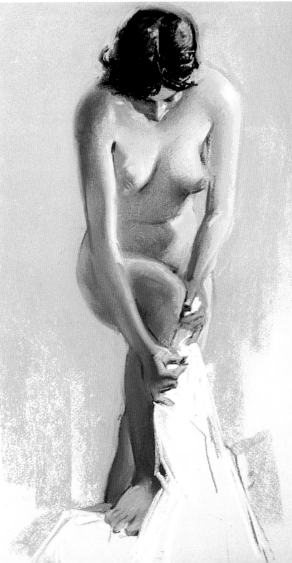

6. To complete the exercise we have painted the darkest areas with the two earth tones. In the skin's lightest areas we have added a touch of lemon yellow and white. Such contrasts give volume to the figure and bring out its three-dimensional qualities.

Flowers

The appealing colors and freshness of flowers have made them a popular theme in pastel painting. Furthermore, they make good subjects because you can paint them conveniently in your studio without worrying about them moving or changing position.

Painting Flowers

The world of flowers contains limitless forms and attractive colors; whether arranged individually or in a bouquet, flowers have a special charm that inspires artists of every sort. However, painting flowers can be a difficult task because they are living subjects whose animate qualities must be conveyed by the artist. So, for the pastel novice, it's a good idea to start by choosing a simple arrangement that will not present many problems of composition or color.

In this exercise we will paint three flowers in a simple glass jar.

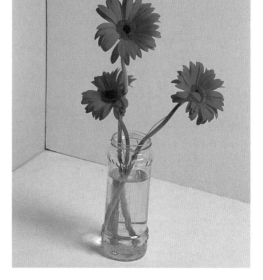

To create this work we will use ten colors: 1. lemon yellow, 2. pozzuoli earth, 3. madder lake deep, 4. gray, 5. thalo blue, 6. black, 7. permanent green, 8. chrome green deep, 9. burnt sienna, and 10. white.

1. After sketching an outline in gray, begin to paint the flowers with pozzuoli earth, using lines to suggest the petals.

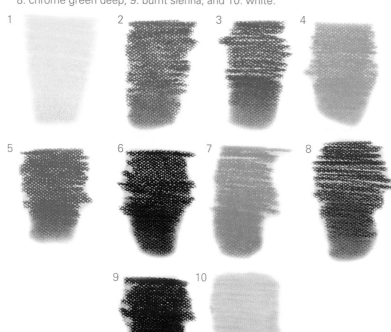

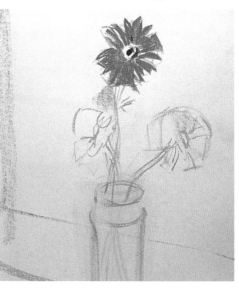

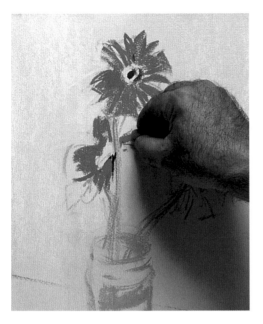

2. Paint the background gray and white to obtain a correct tonal value. After painting the stems, paint the flower petals that appear behind them.

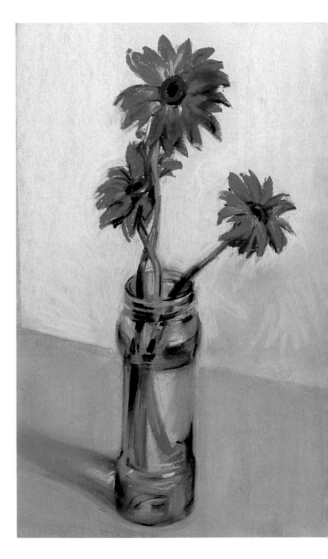

3. At this point we have completed the basic forms. Now we begin to create volume and detail.

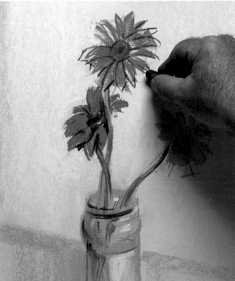

4. With black, give shape to the petals and define the jar's form.

5. We have put a few touches of yellow in the petals; when mixed with the background, they produce an orangish color. With blue we have painted the jar's shadow on the table, blending it with a finger in the direction of the light.

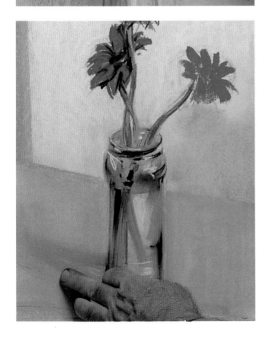

6. Finish painting the flowers with touches of burnt sienna in the dark areas and gentle touches of white in the light areas. Look at how the light in the jar and its shadow is brought out with yellow. Note also how the entire work is based on a contrast between the warm colors of the flowers and the predominantly cool colors of their surroundings. This makes the flowers stand out and heightens the appearance of freshness and life.

Vegetation

It's easy to find an outdoor motif to paint from the world of plants. The countryside, which will be our focus, is not the only place to find good subjects. Vegetation can be found anywhere, whether in a garden or city park.

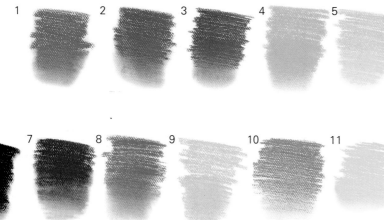

Painting Vegetation

Diversity in the plant world is endless. Each time you paint a motif from this realm you will find new colors and forms to portray. Despite this, the process essentially remains the same as for other motifs: creating forms with stains and developing volumes with light and shadow.

We have chosen two pine trees for our plant exercise. They will provide a good example for practicing the technique.

The eleven colors used in this picture are divided into two groups. For the pines we will use: 5. ocher, 4. permanent green, 3. chrome green deep, 10. burnt sienna, 7. raw umber, and 6. black. For the surroundings we have chosen 1. thalo blue, 2. ultramarine deep, 8. madder lake, 9. gray, and 11. yellow

1 2 3 4 5

6 7 8 9 10 11

1. Once you have sketched an outline with carbon pencil, paint the area of the pines with ocher. Try to draw the lines to help suggest the direction of the pine needles and the uprightness of the trunk.

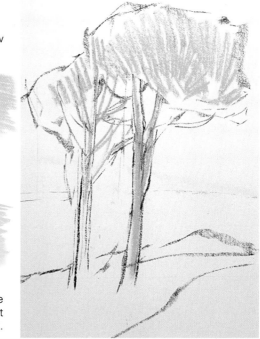

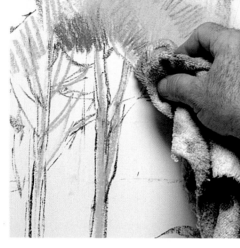

2. Apply a few lines of each green and blend the colors with a cloth.

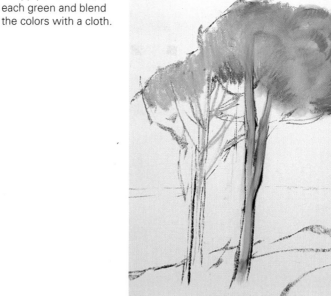

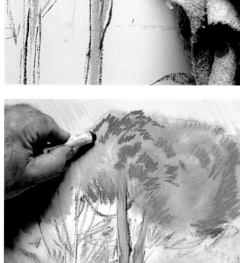

3. Once these colors are blended, paint over them with burnt sienna to bring out the dry vegetation and partial shadows.

4. After painting the sky, begin to work on the trees' shadows with chrome green deep. Remember to bring out the long and thin qualities of the pine needles with the lines you draw.

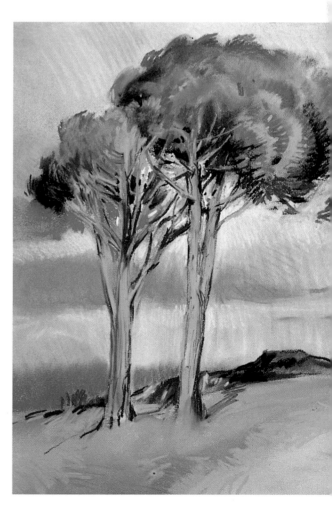

5. At this point we have basically completed the foliage, all that remains is to give more detail to the pine on the right and paint the texture of the trunks.

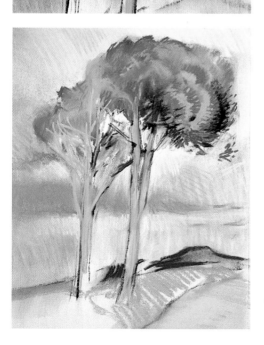

6. We finish this exercise by retouching the treetops with lights and darks. We have brought out the trunks' texture with fine lines of yellow and both earth tones.